W9-CEH-205

EDWARD GOREY

THE EPIPLECTIC BICYCLE

HARCOURT BRACE & COMPANY
New York San Diego London

Copyright © 1969 by Edward Gorey
Copyright renewed 1997 by Edward Gorey

All rights reserved. No part of this publication may be reproduced or transmitted in any form or
by any means, electronic or mechanical, including photocopy, recording, or any information
storage and retrieval system, without permission in writing from the publisher.

Requests for permission to make copies of any part of the work should be
mailed to: Permissions Department, Harcourt Brace & Company,
6277 Sea Harbor Drive, Orlando, Florida 32887-6777.

Library of Congress Cataloging-in-Publication Data
Gorey, Edward, 1925–
The epiplectic bicycle/Edward Gorey.
p. cm.
ISBN 0-15-100314-9
I. Title.
PS3513.0614E6 1998
813'.54—dc21 98-15370

F G E

Printed in Singapore

For Ruth Reark

PROLOGUE

It was the day after Tuesday and the day before Wednesday.

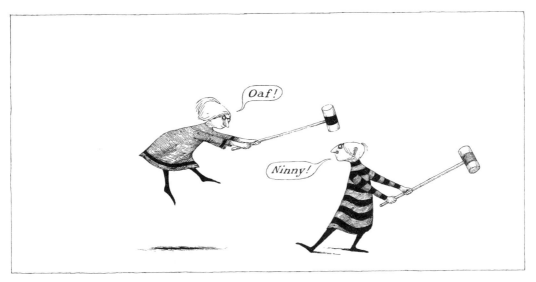

CHAPTER ONE

Embley and Yewbert were hitting one another with croquet mallets

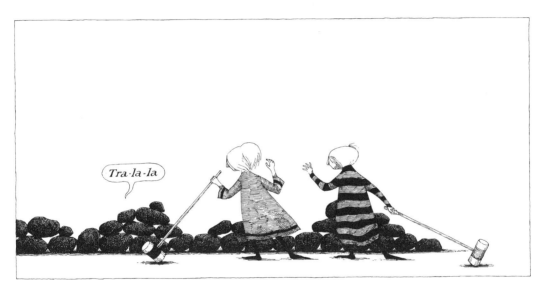

when they heard a noise behind the wall

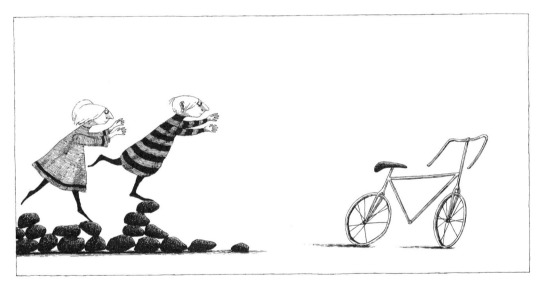

and an untenanted bicycle rolled into view.

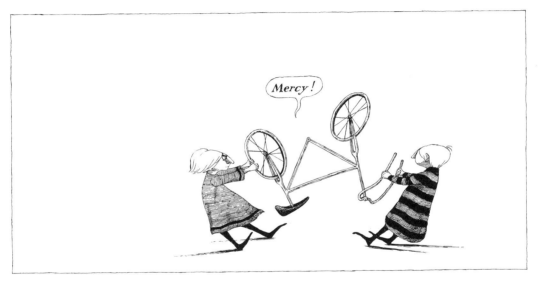

CHAPTER TWO

Brother and sister tried to take sole possession of it

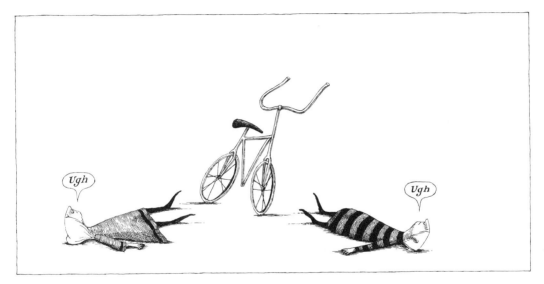

until they both fell exhausted;

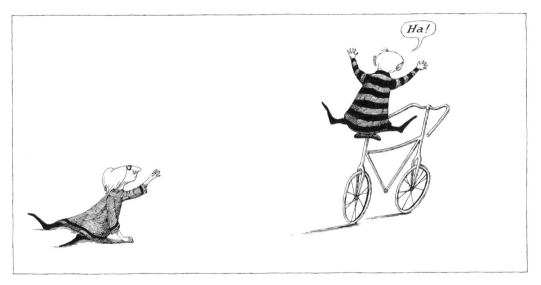

Yewbert recovered first and leapt onto the seat

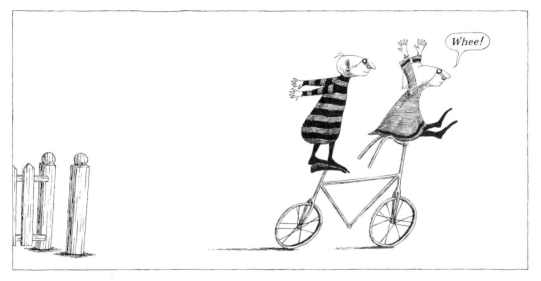

so Embley had to sit on the handlebars as they flew out the gate.

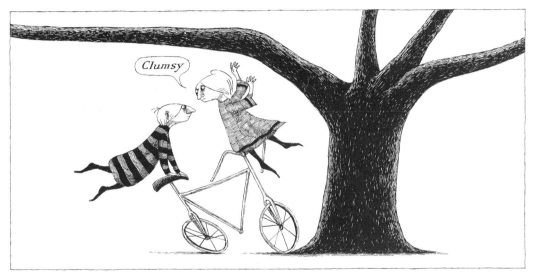

CHAPTER FOUR

After that they almost ran into a tree

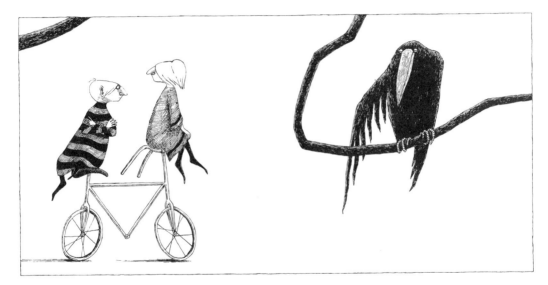

on which was perched a large bird

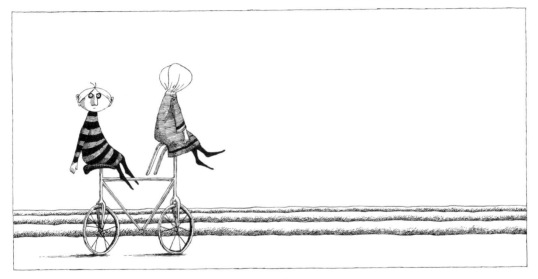

They rode past a great many turnip fields

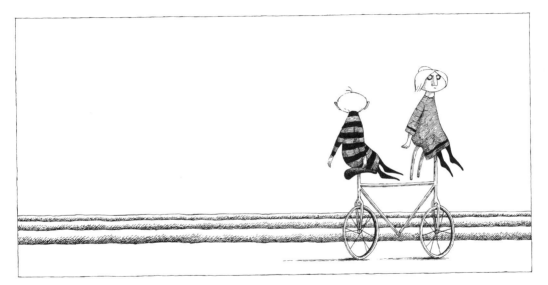

but as it was the wrong time of year, they didn't see any turnips.

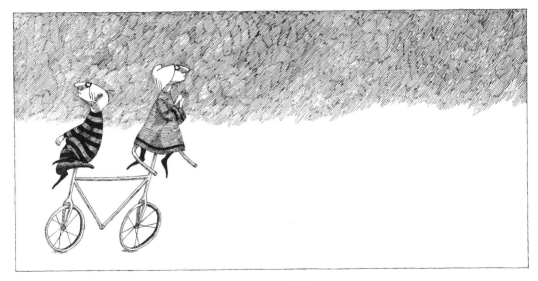

CHAPTER ELEVEN

A horrid storm came up ;

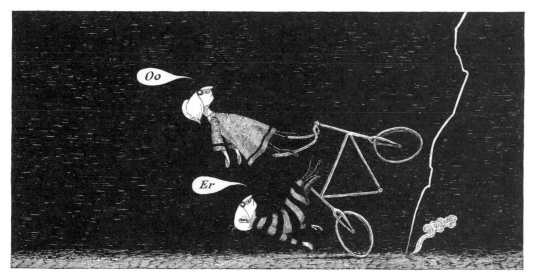

they were nearly *struck by* lightning

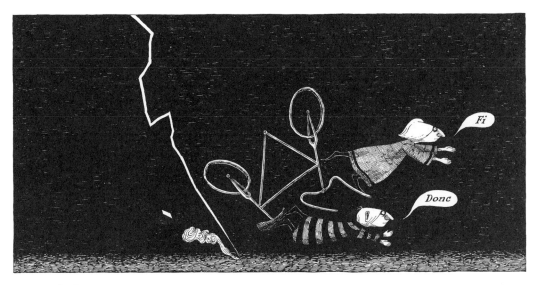

several times.

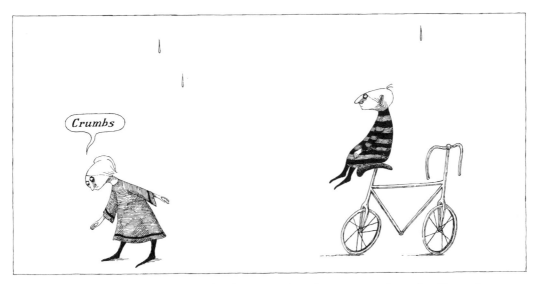

When it was over Embley found she had lost her fourteen pairs of yellow shoes

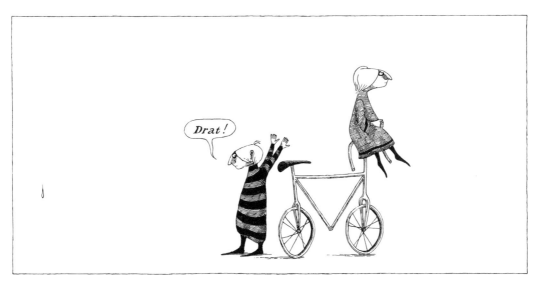

and Yewbert his spotted-fur waistcoat.

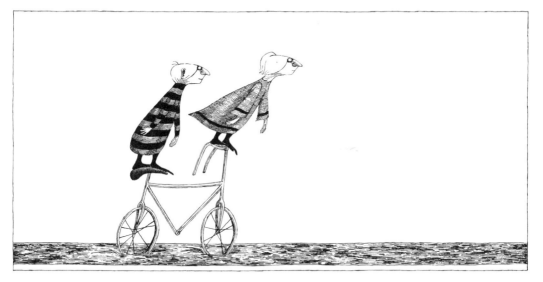

CHAPTER TWELVE

As they were riding through a lengthy puddle

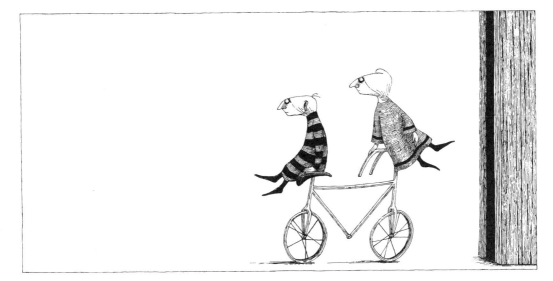

CHAPTER FIFTEEN

They took a wrong turning and before they knew it, were entering a vast barn;

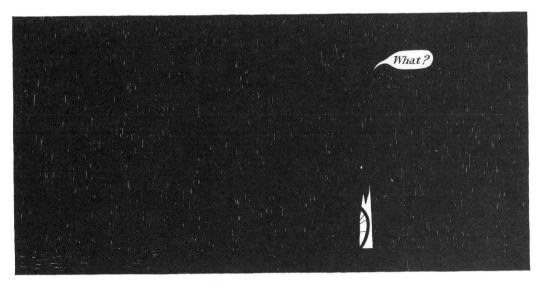

it was too dark to hear anything;

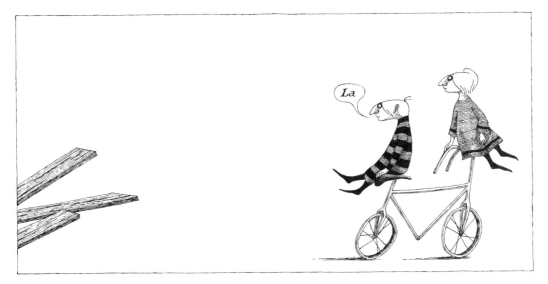

it fell down as they came out the other end.

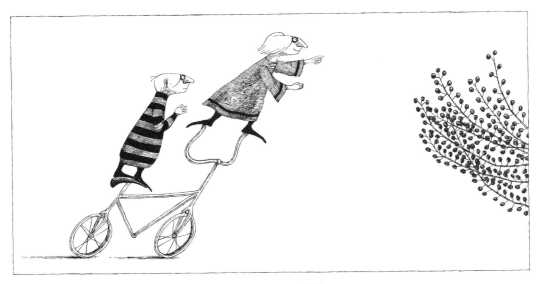

They made for a huge bush

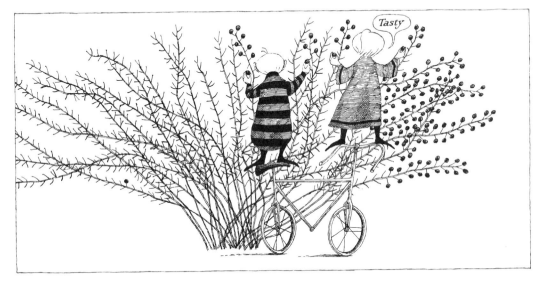

off which they rapidly ate a quantity of berries.

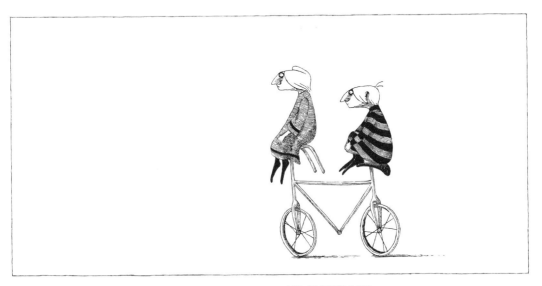

CHAPTER TWENTY-TWO (AND THE LAST)

They returned home

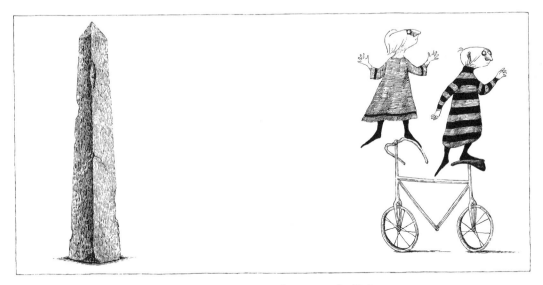

to discover there was nothing to be seen but an obelisk

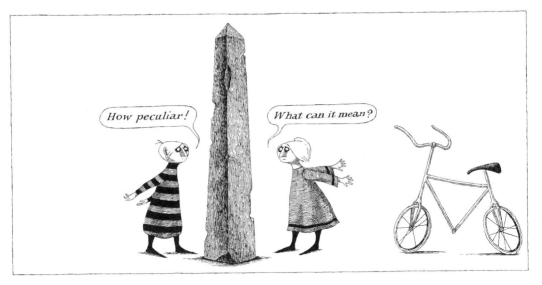

which said it had been raised to their memory 173 years ago;

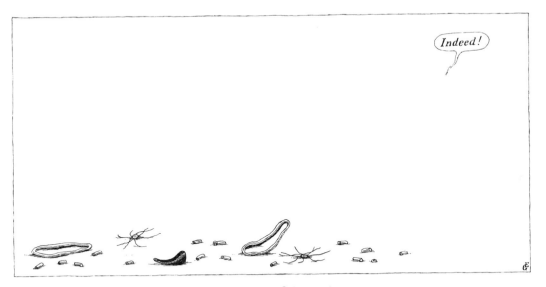

the bicycle uttered for the last time and fell to bits.